Landfill

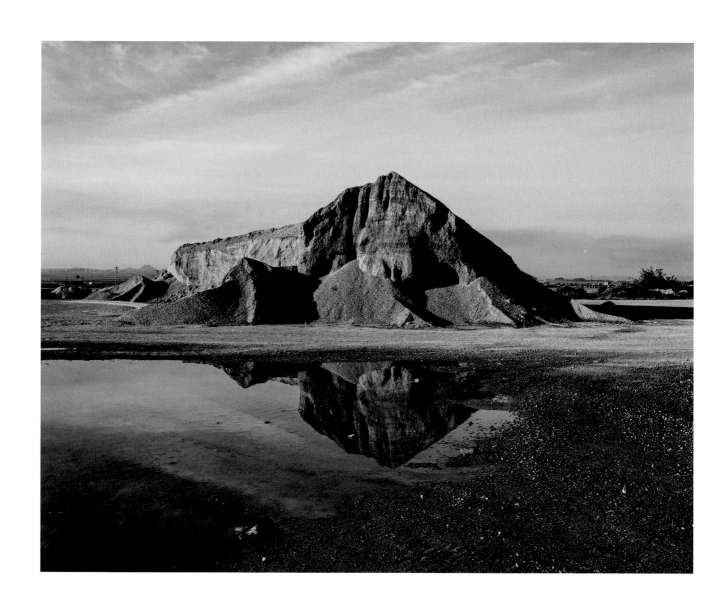

Landfill
Brett Kallusky

ELEGY FOR THE SANTA MARIA VALLEY

with an afterword by
Matthew Coolidge

George F. Thompson Publishing
in association with
the Minnesota State Arts Board
and Center for the Study of Place

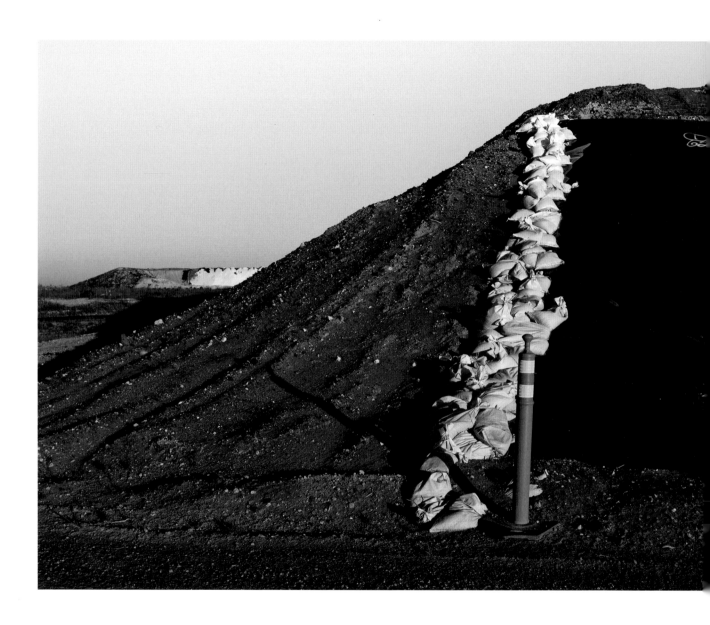

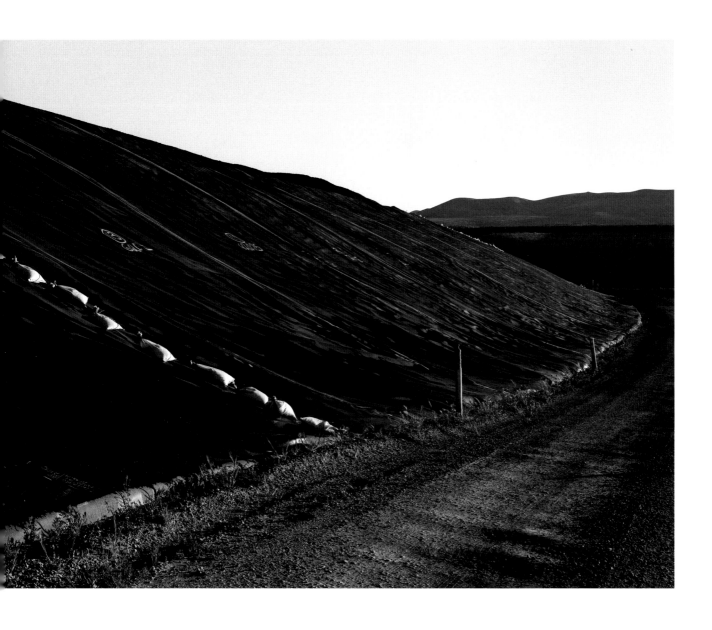

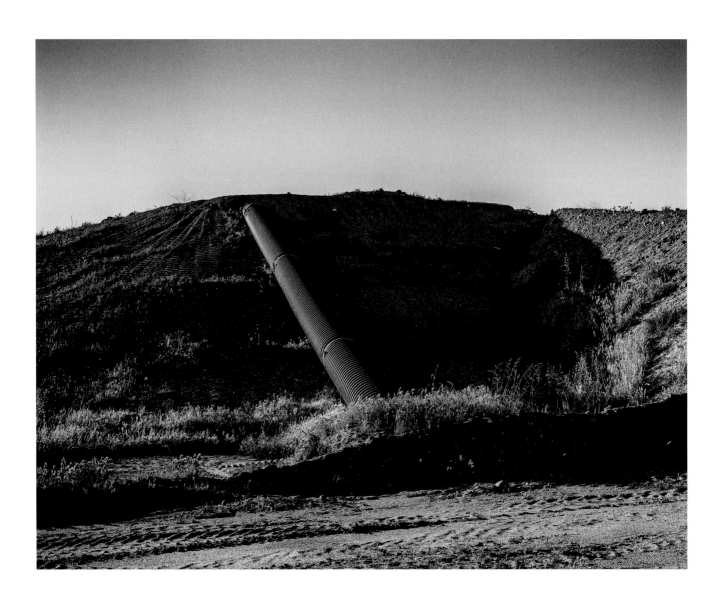

For Elsa

Plastic represents the promises of modernity: the promise of sealed, perfected, clean, smooth abundance. It encapsulates the fantasy of ridding ourselves of the dirt of the world, of decay, of malfeasance."

—HEATHER DAVIS, "LIFE AND DEATH IN THE ANTHROPOCENE" (2015)

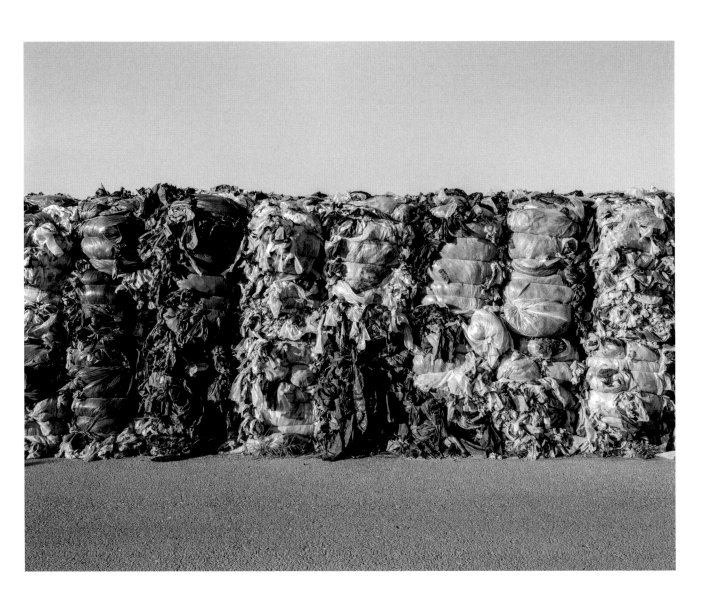

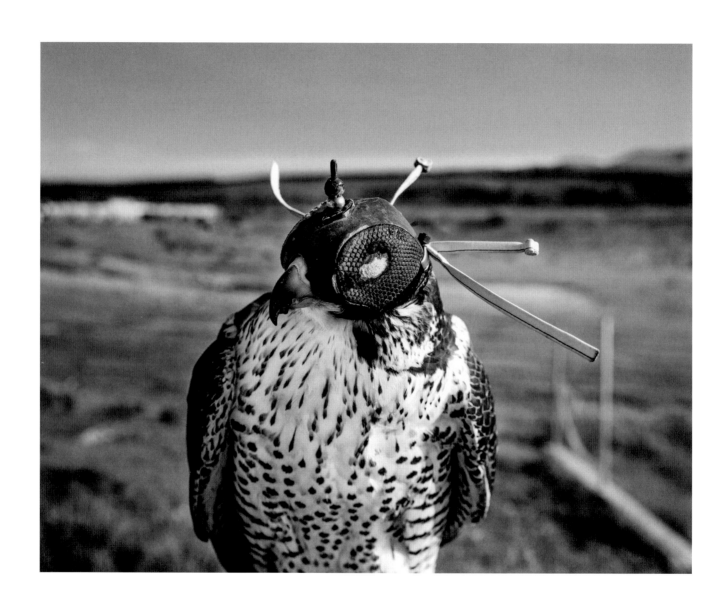

The View from Sugar Street

Since 2013, I have been photographing in the Santa Maria Valley in Central California. This historic place, with its strong roots in Indigenous and Spanish-American cultures, is a reflection of a much larger cycle of production, consumption, and waste. It is filled with visual juxtapositions: a place of verdant hills defined by world-renowned vineyards and a valley floor filled with vast rows of crops that conceal millions of tons of garbage and industrial refuse. The lyrically named Sugar Street—the street in the Santa Maria Regional Landfill that runs parallel to the adjacent Santa Maria River—is situated directly alongside tens of thousands of acres of agricultural fields, where crops such as broccoli, carrots, cauliflower, celery, lettuce, squash, and strawberries are grown on a massive scale for consumption by Americans everywhere—coast to coast.

I'm intrigued by the visual and conceptual dissonances that present themselves here: the perfect, iconic forms of commercially grown produce; the carefully organized chaos of the waste-intake sites; the ever-changing engineered hills of the capped landfill cells, where native wildflowers have returned to grow on repurposed, non-hazardous soil once containing oil. Nestled among these contrasts are the hulking forms of baled and stacked tonnage of agricultural plastic, alternately resembling massive boulders or fortified walls, comprised of the same material that is used for insulation and irrigation in the tidy but expansive as-far-as-the-eye-can-see rows of rotational crops nearby.

Plastic winds its way through this engineered landscape like a dark, opaque river. Sheets of it are used above the soil as an exoskeleton, warming the raised ground and protecting the strawberry plants whose roots are wrapped in, and watered by, an engineered cocoon. All the while, hawks dutifully keep watch over the 50-year-old, state-of-the-art landfill that is nearing the end of its life. It is running out of land.

The plastic tubing that is used for irrigation, once it is retired from the fields, is formed into bales of several hundred pounds each, leaving immense but temporary ramparts and parapets in the landscape. This tubing may be shipped out to be recycled in Asia and made into garbage bags, setting the stage for a return to America's landfills months or years later. At other times, the compressed bales are used to reinforce the plastic lining of the landfill cells, forming (we are told) impermeable walls underground to guard against leeching.

The Santa Maria Valley has a deep human history that began some 10,000 years ago with the Chumash people who lived throughout the interior and coastal areas of the region and who are historically known for their complex basketry and vivid pictographs. Today, the Chumash Nation has around 5,000 members. Everything changed for the Chumash when Spain claimed California as its own territory in 1542 following its "discovery" by Juan Rodríguez Carbrillo (1499–1543). The influence of Spanish rule and cultural practices (especially religious and agricultural, which were forcibly introduced) on the Chumash cannot be overstated, and that Spanish influence is ever present today in the Valley.

The war between Mexico and the United States (1846–1848) ultimately set in motion statehood in 1850 and the modern Santa Maria Valley landscape we see today, in which agriculture and viticulture remain a dominant presence, a legacy of Spanish times. Outsiders may be surprised to learn that agriculture is the number-one economic force in Santa Barbara County, whose farms and ranches grossed $1,521,520,492 in the last pre-COVID-19 year of 2019 (City of Santa Barbara). About 52,535 of those acres were irrigated cropland, with the great majority (87 percent) in truck crops, specifically rotational vegetables (30,140 acres) and strawberries (13,755 acres).

An enormous amount of water is required for irrigating crops on such a massive scale—nearly 103,150 acres/foot in 2019—with rotational vegetables comprising by far the greatest component, about 71,580 acres/foot, primarily because about 69 percent of the total acreage was dedicated to those crops. Strawberries comprised the next-largest crop acreage and had an associated water requirement just under 19,850 acres/foot (City of Santa Maria). For water that is stored or impounded, the acre-foot is how water is measured: 1 acre-foot = 325,851 gallons of water = 1,233 cubic meters of water. While the amount of

water used to support farming at this scale is alarming, of greater concern is the quality of water that is left for public consumption, with deleterious nitrate levels at higher-than-acceptable levels in the aquifers beneath the Central Valley of California.

Given the Valley's location near the oil-rich Pacific waters off the Santa Barbara Coast, San Luis Obispo and Santa Barbara Counties have had their fair share of calamitous environmental events and contaminated locations associated with oil. These include, most recently, the superfund site in Casmalia, where 4.5 billion pounds of petroleum-based and other hazardous waste were transported to a disposal facility there from 1973 until its closing in 1989, and the massive out-of-control Union Oil Tank Fires at Avila Beach in 1908 and San Luis Obispo in 1926, where three workers were killed.

The Santa Maria Valley is a hard-working place, all in service economically to the region and nation: food, oil, and wine. With so much human use and impact on the land, the Valley today exists as a carefully calibrated human and natural ecosystem, constantly negotiating the balance between the Valley's environmental capacities and its agricultural production, waste, and renewal, between containment and regeneration, resilience, and transformation. The process of covering, wrapping, and burying our waste—alongside the sculpting, hollowing out, and harvesting of the earth—occur here on an industrial scale.

The landscapes of the Santa Maria Valley have an uncanny resonance everywhere, as Americans undertake these same processes in their ordinary lives: ritual human actions that mark the passage of time through the landscapes and landfills we create. In this sense, the subject of these photographs—the hidden side of Central California's historic Santa Maria Valley—is both a microcosm and macrocosm of modern-day America. And every time someone living elsewhere bites into a tasty Valley-grown strawberry, cauliflower, or carrot or drinks a splendid Valley wine, this book is a reminder of everything they cannot see that went into their creation.

Landfill

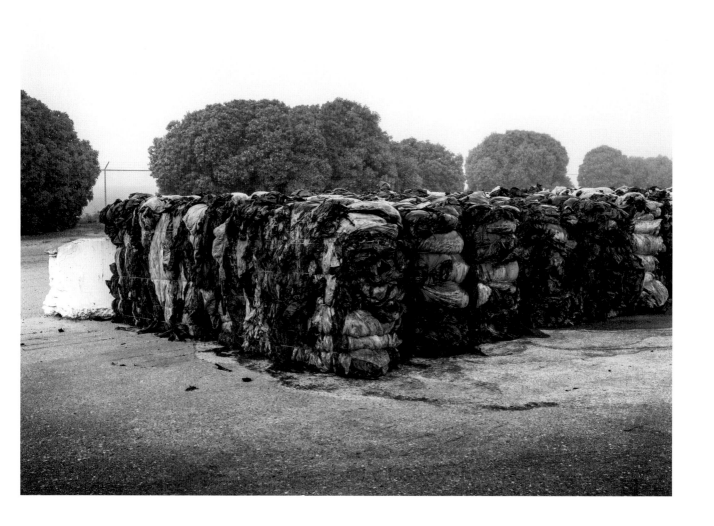

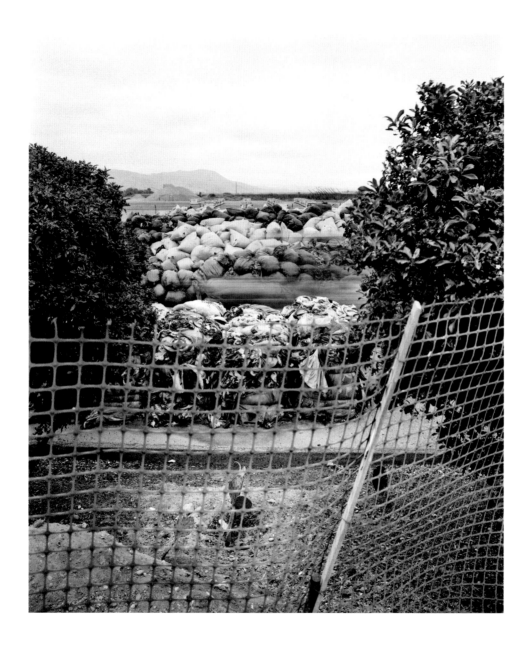

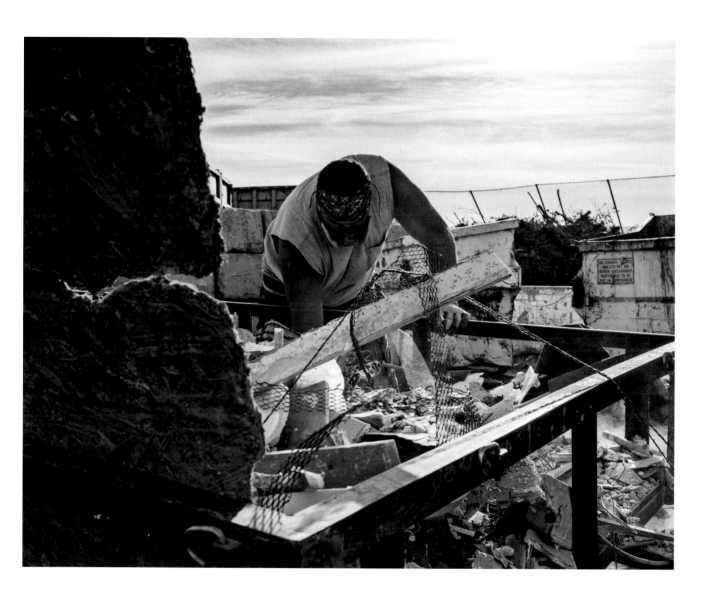

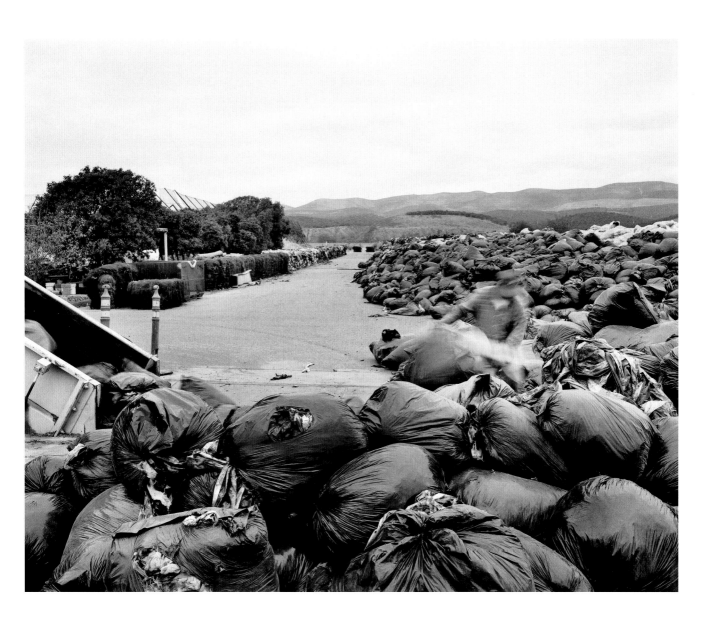

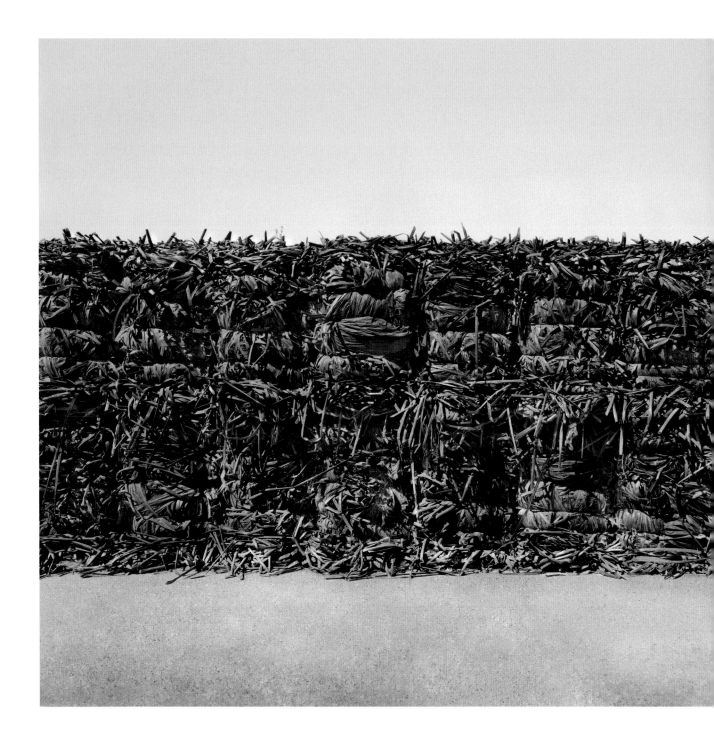

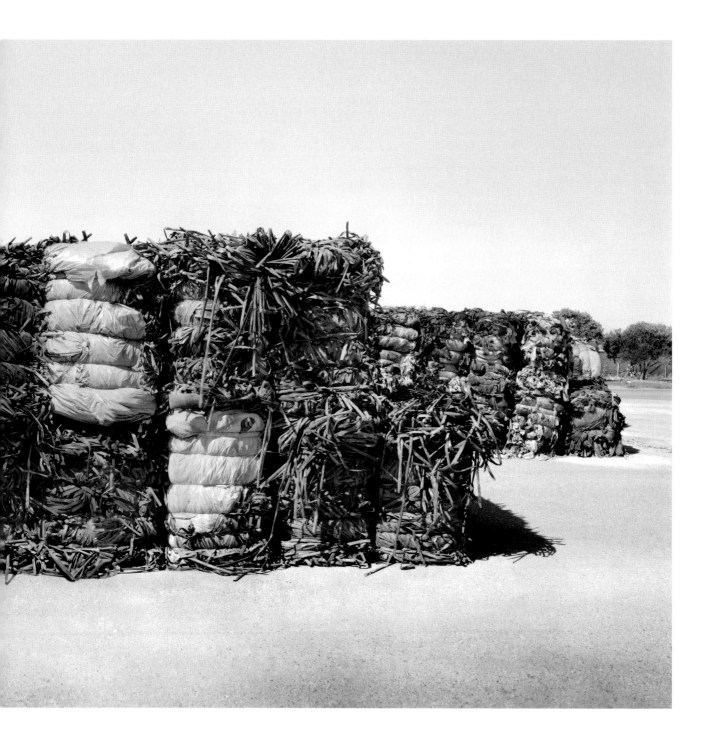

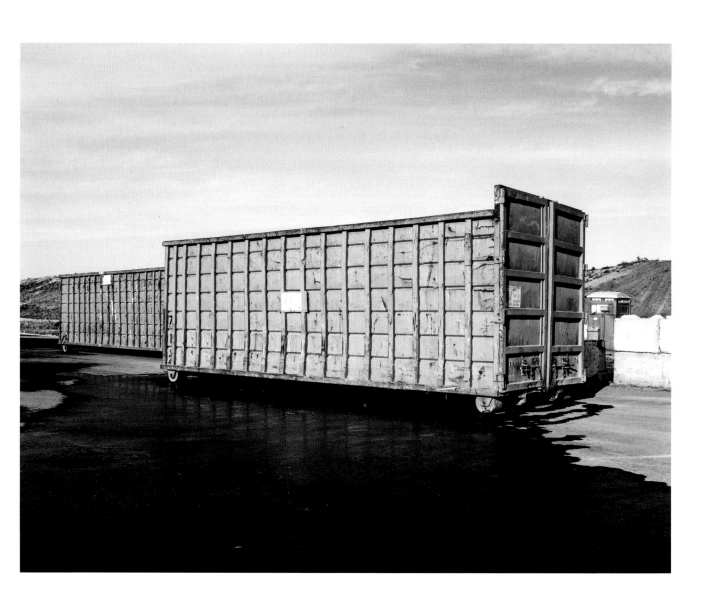

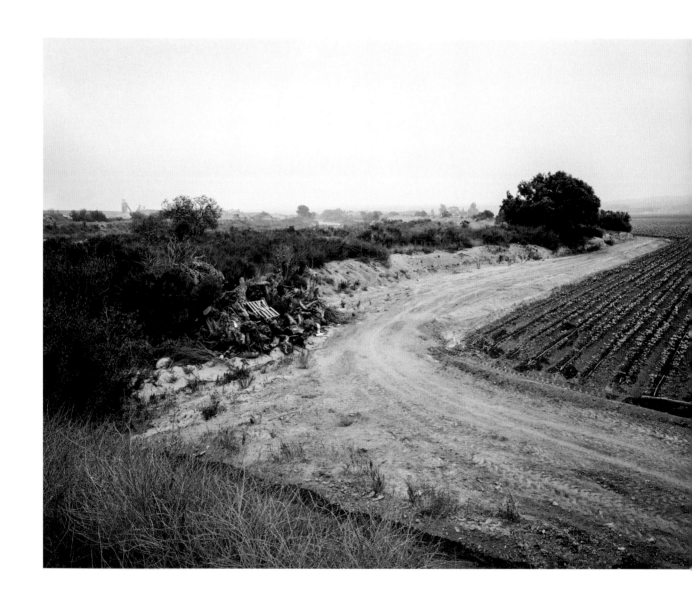

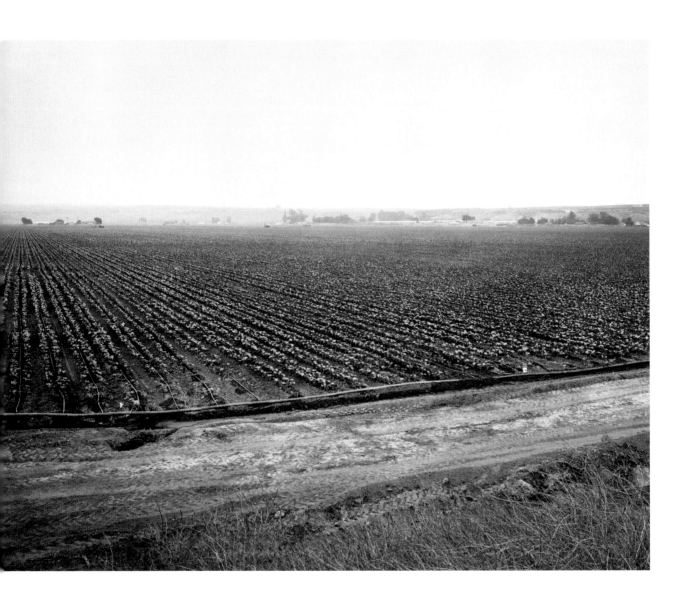

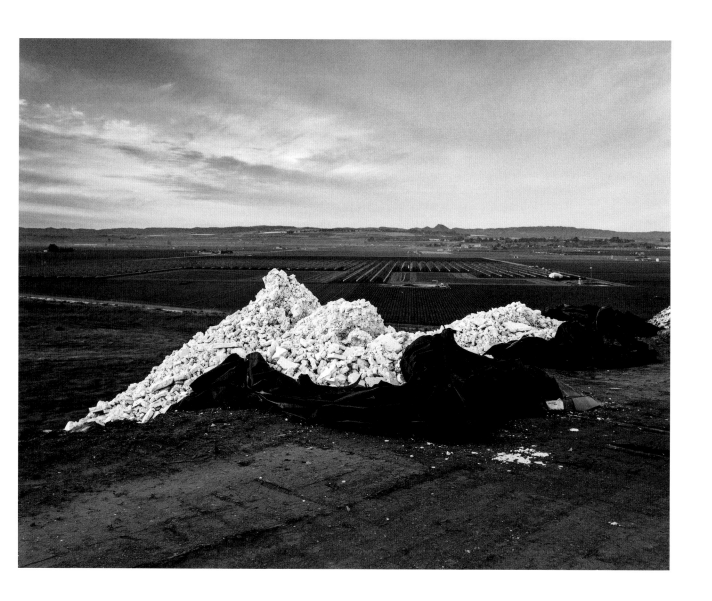

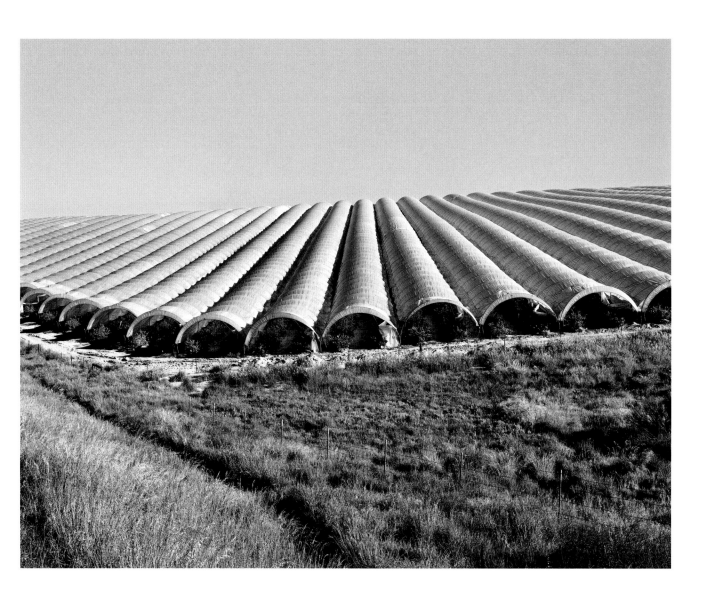

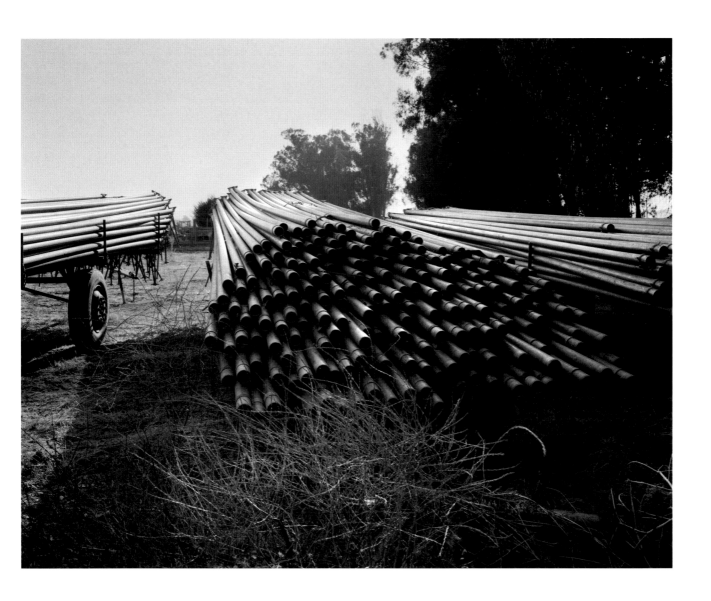

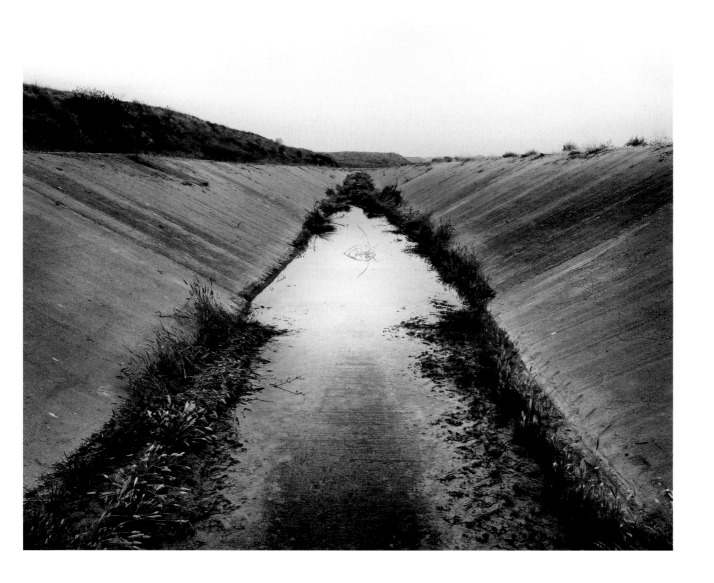

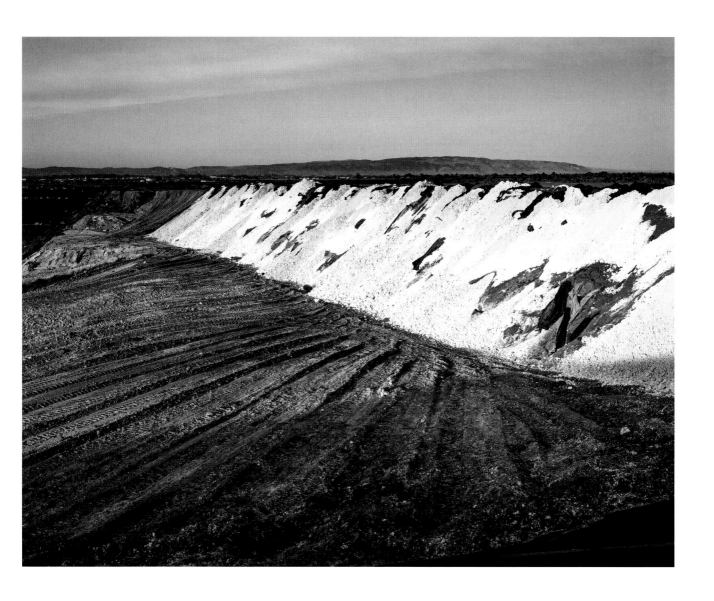

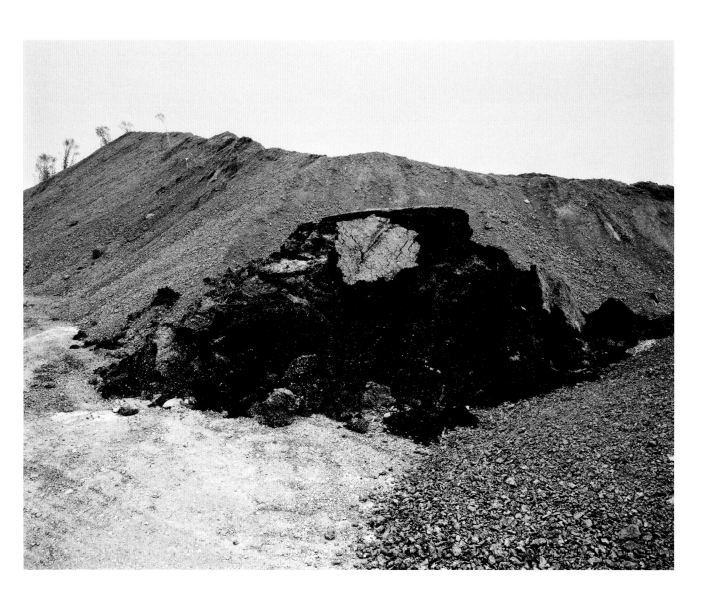

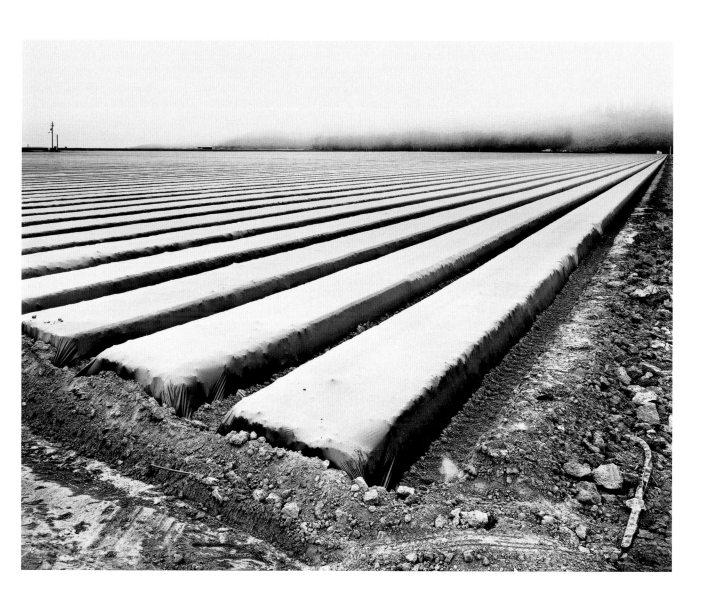

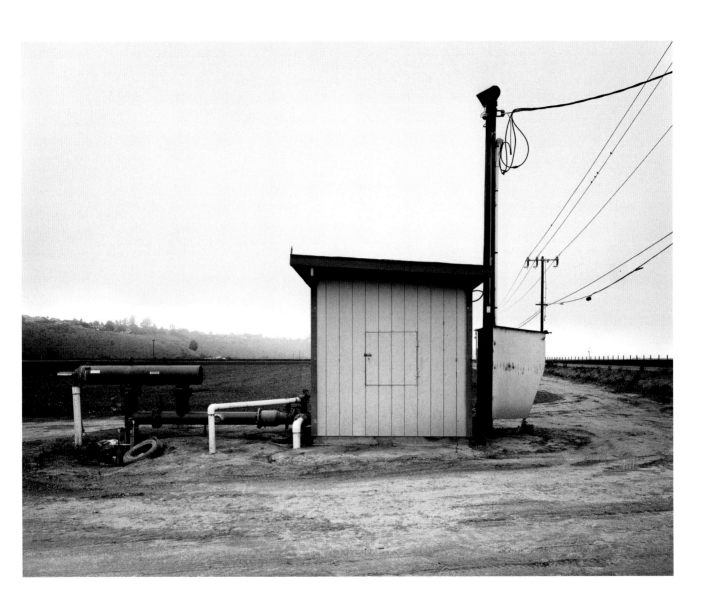

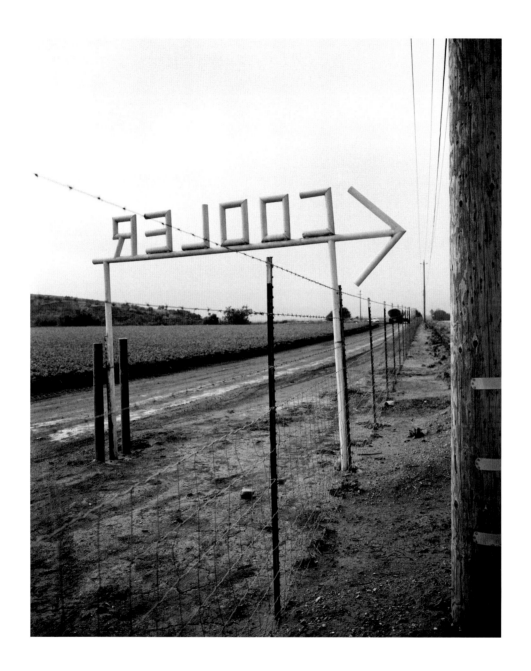

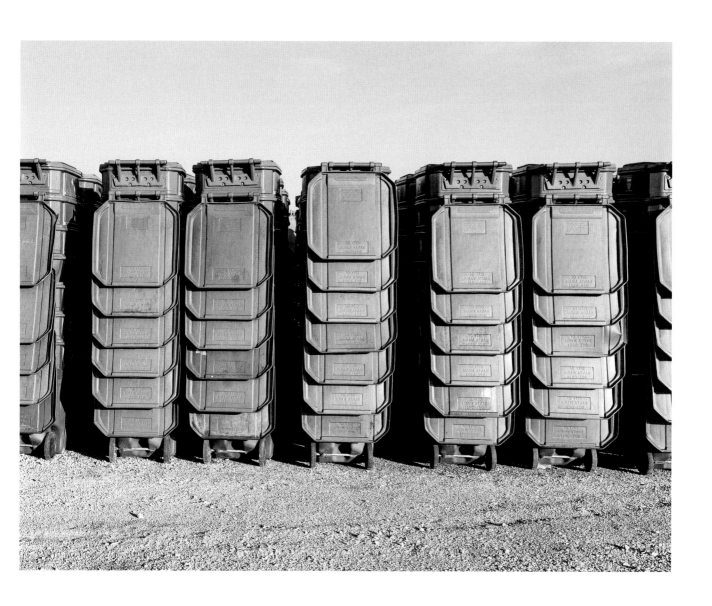

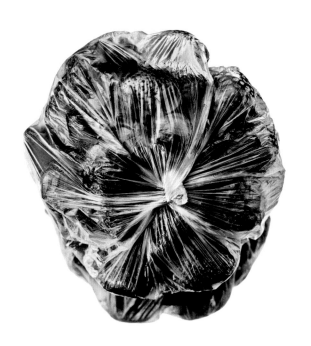

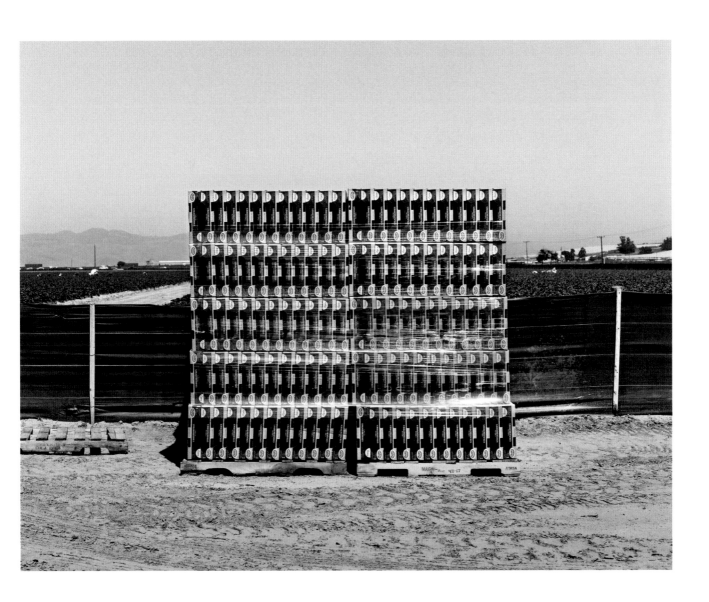

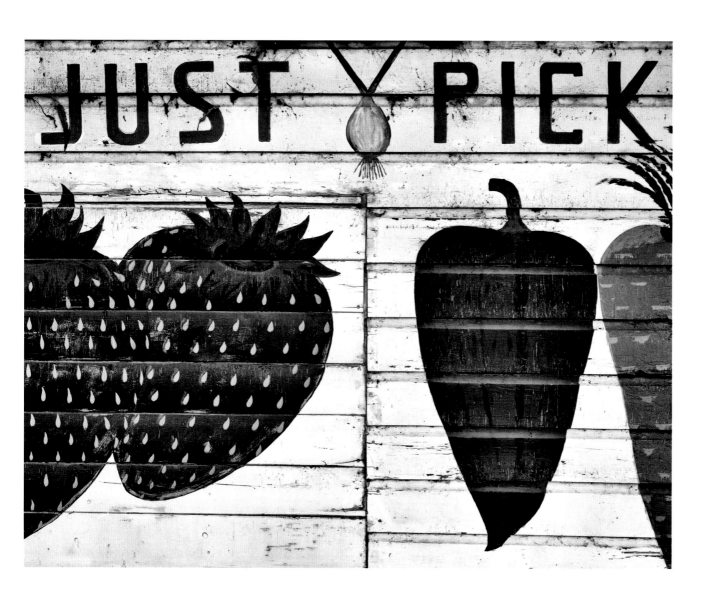

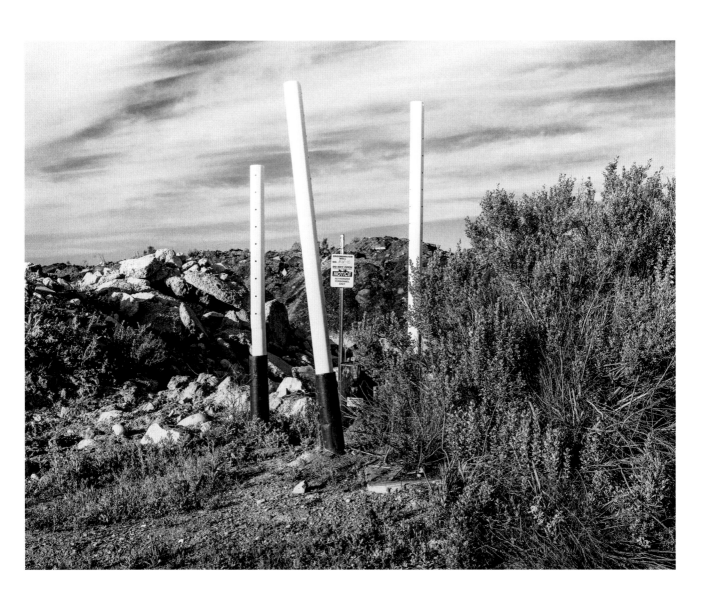

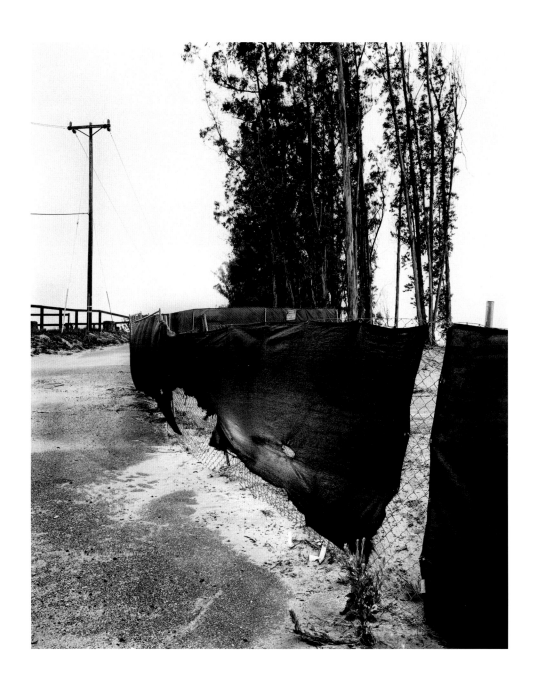

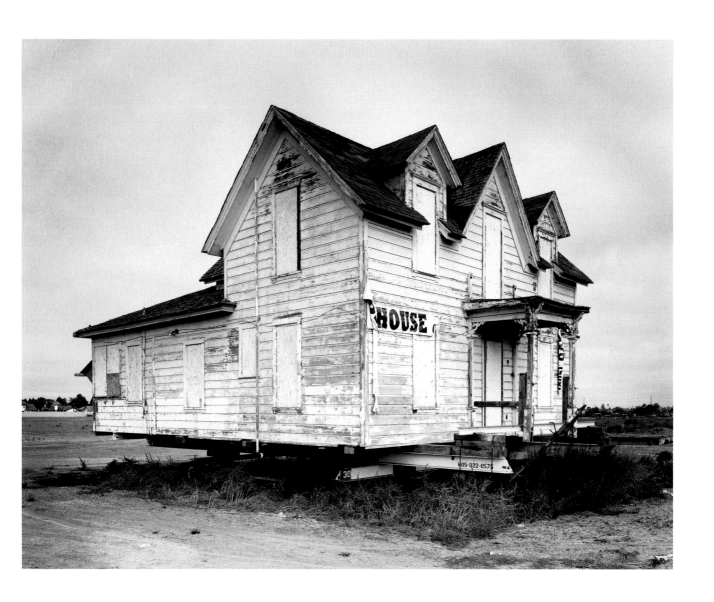

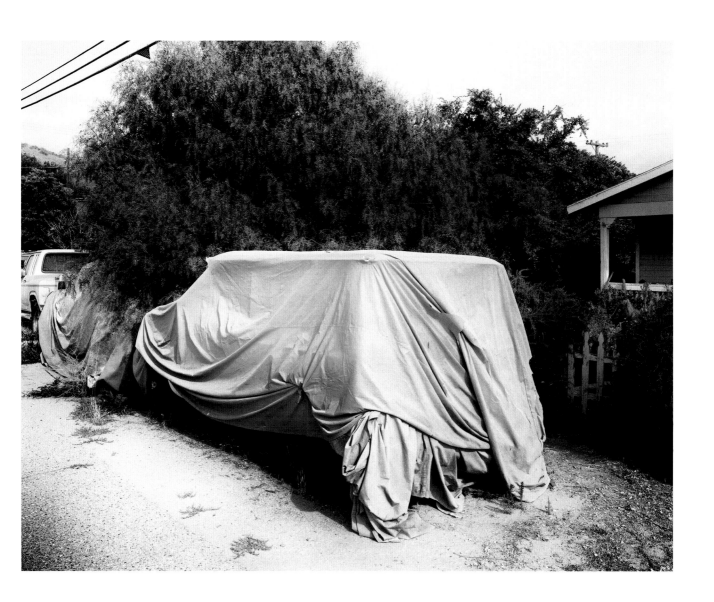

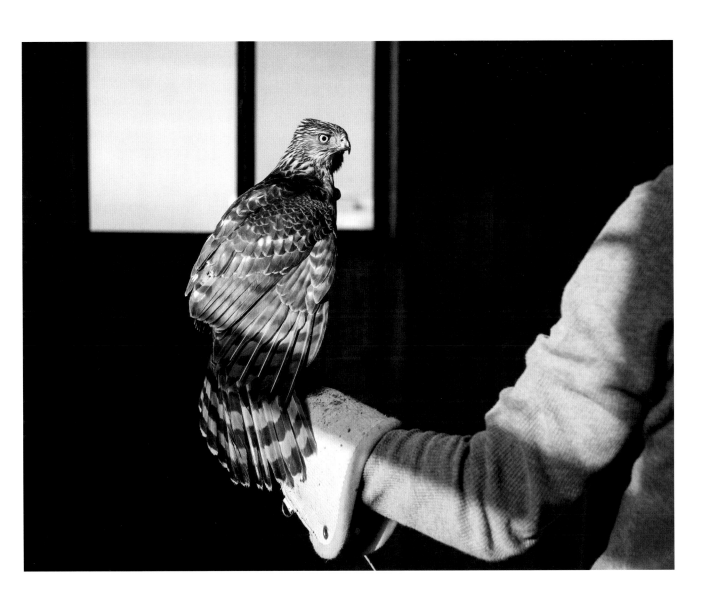

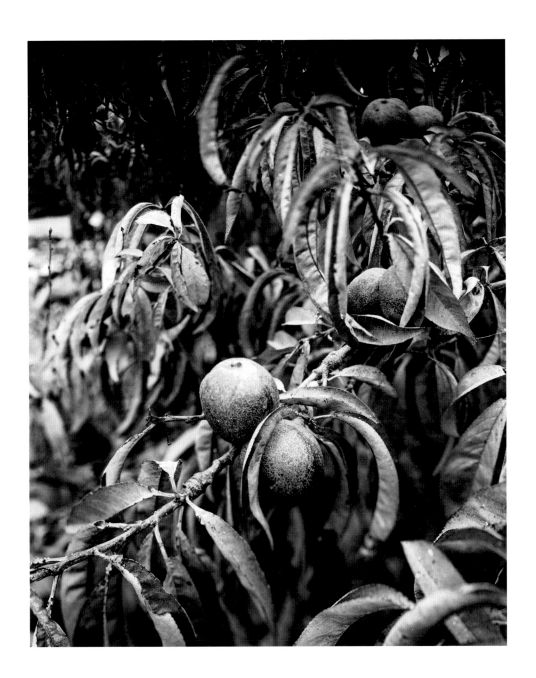

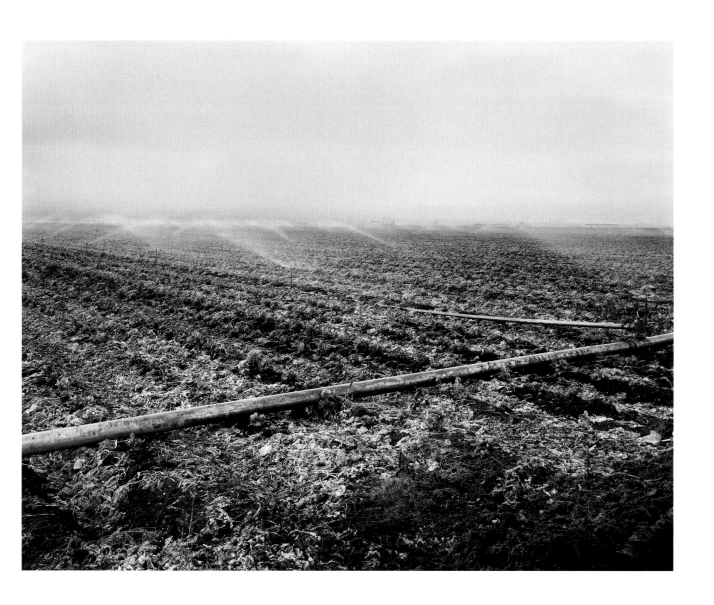

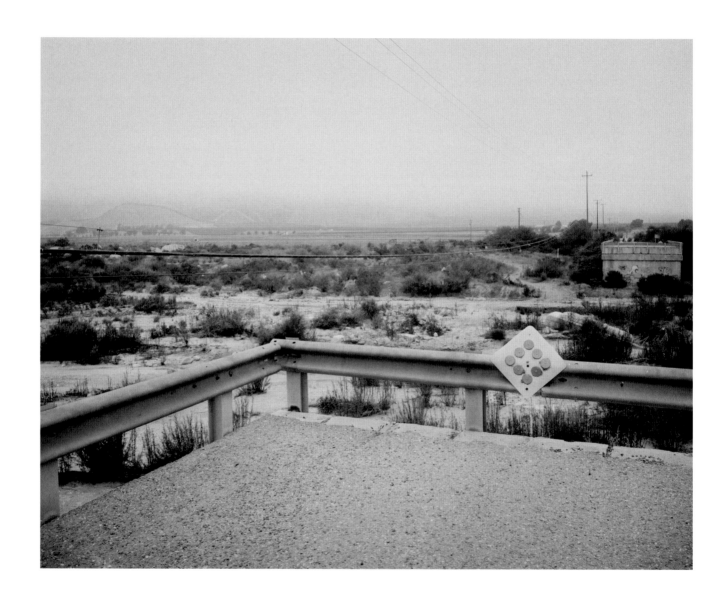

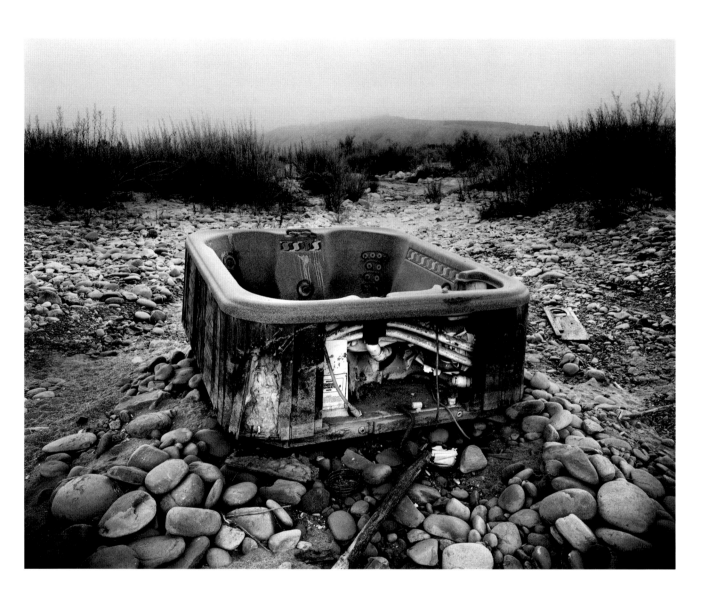

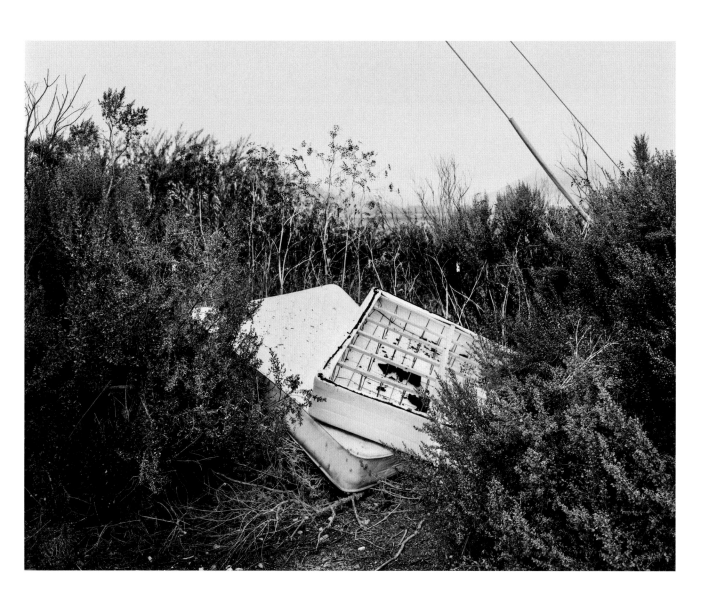

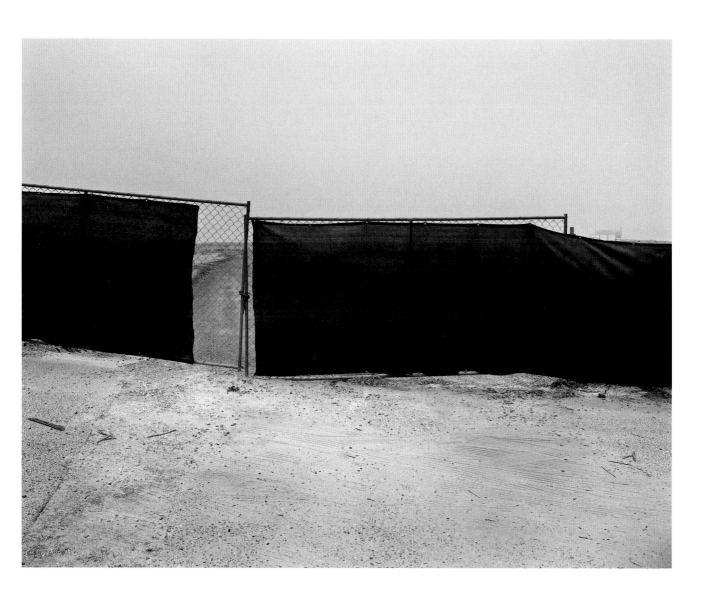

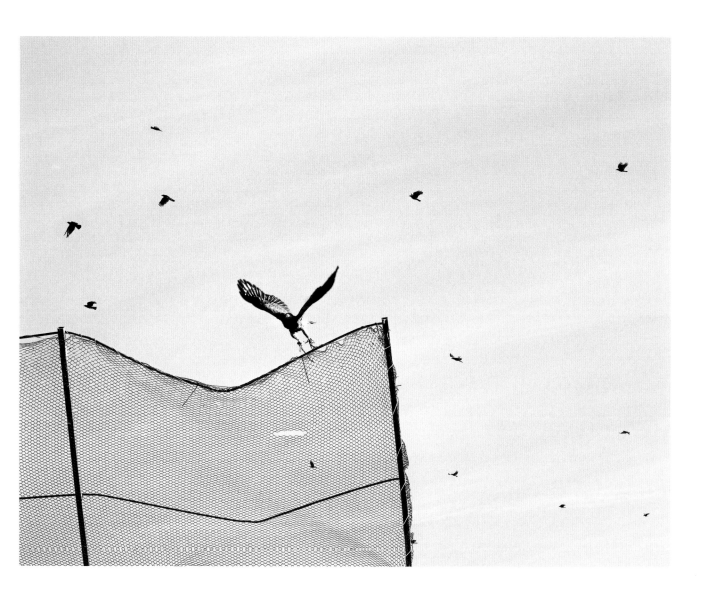

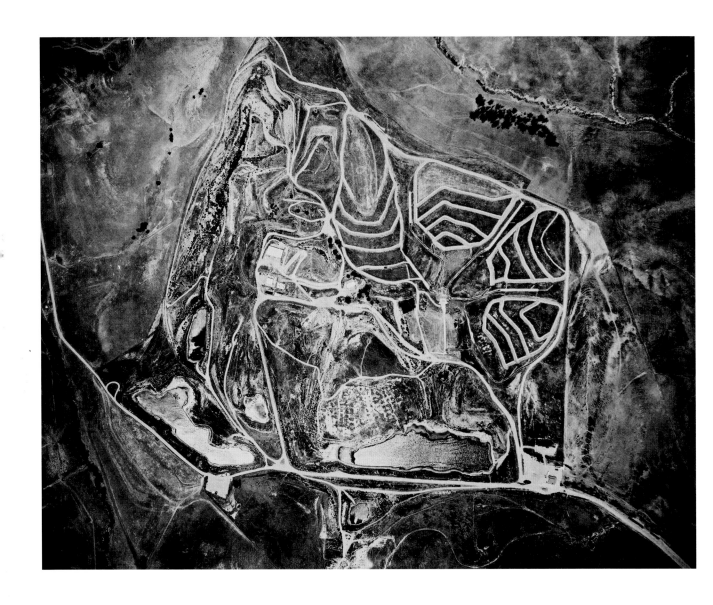

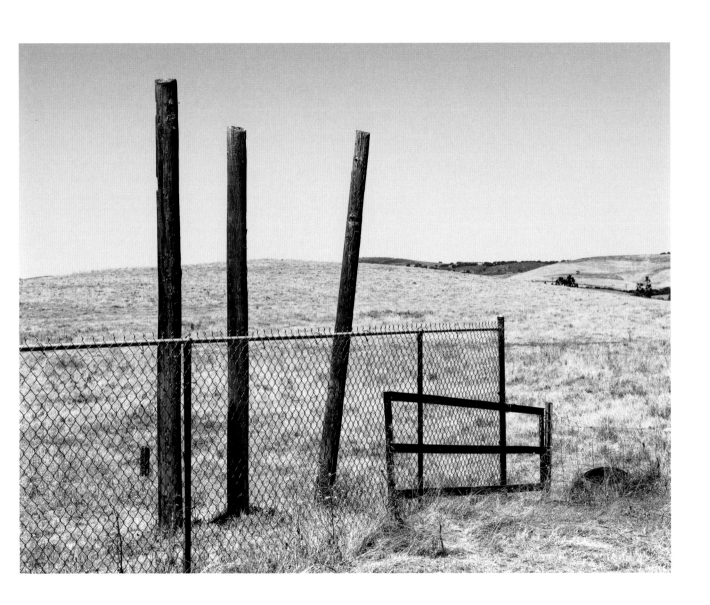

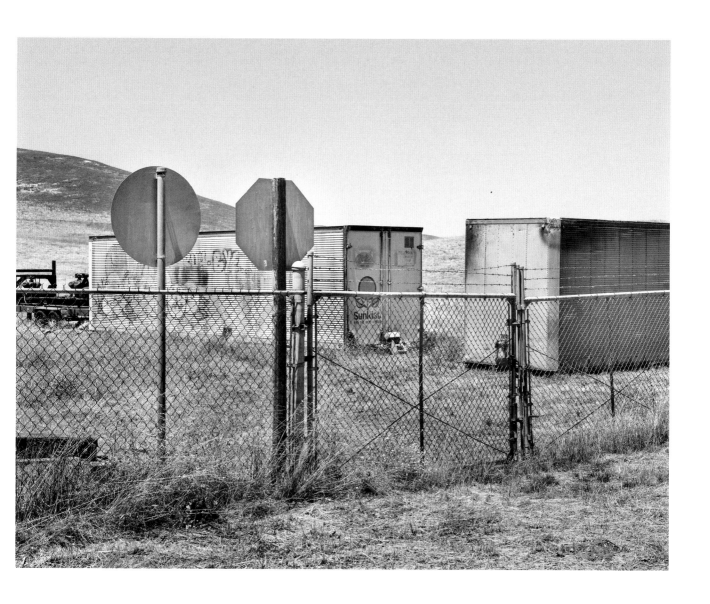

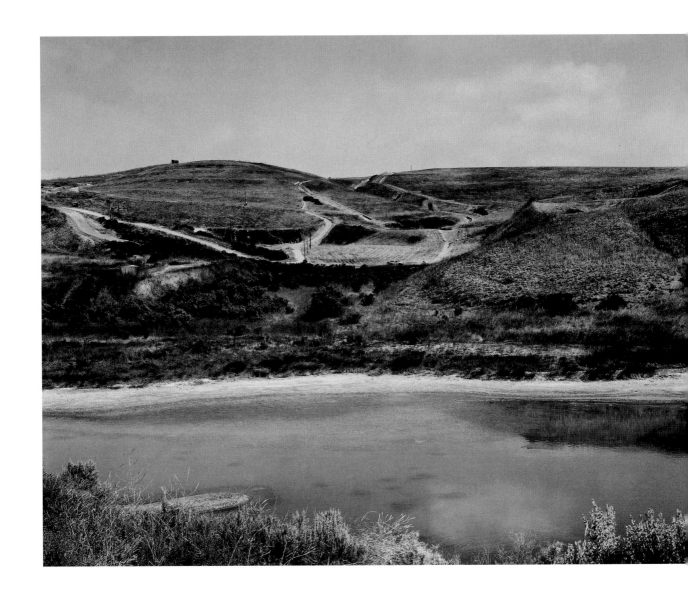

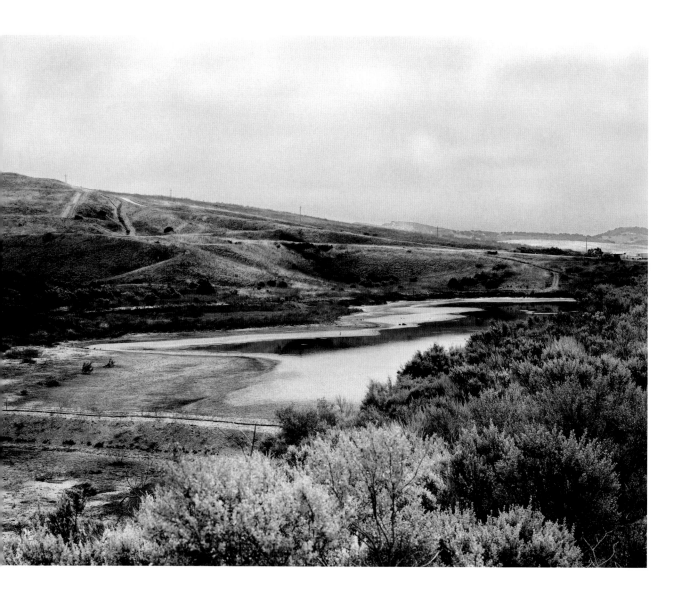

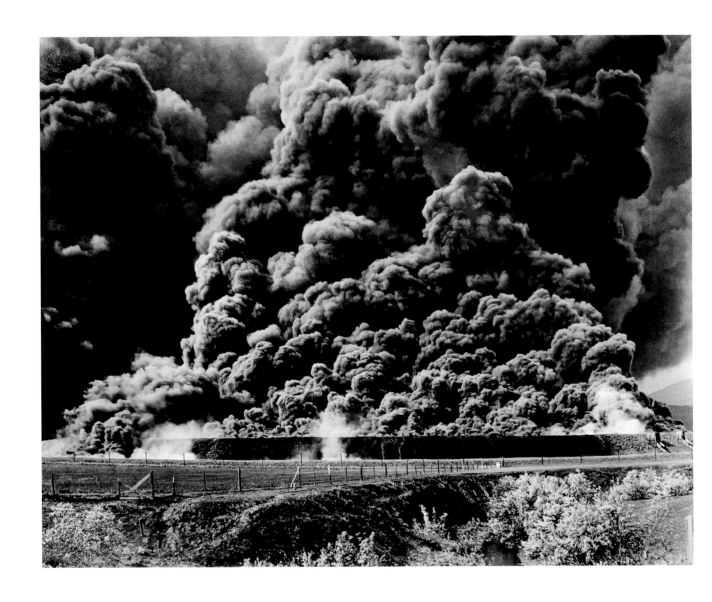

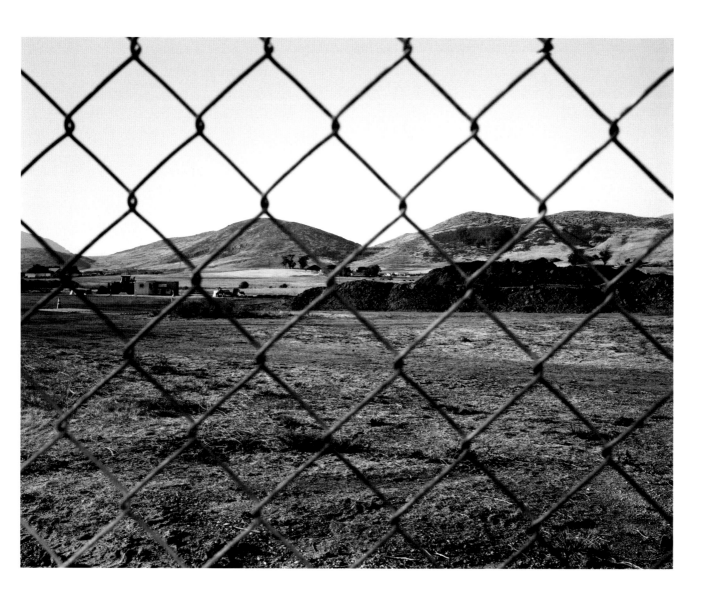

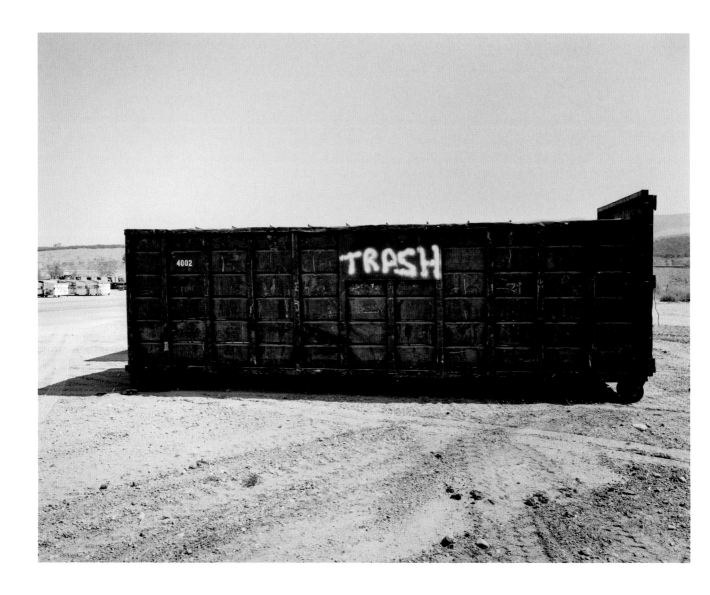

Santa Maria's Ground Truth
Matthew Coolidge

The Santa Maria Valley may at first seem ordinary and its selection for special attention by a photographer as perceptive and inquisitive as Brett Kallusky seem arbitrary. But that may be the point. Any place can be broken down, under scrutiny, into parts and reassembled into a narrative by an able interpreter to construct a compelling tale of our times. It's all in the telling.

Most valleys are formed and named by the river that flows through it. Like other valleys in the American West, Santa Maria Valley's eponymous river doesn't often have much water in it and, most of the time, in most places, none. A dry river could be seen as oxymoronic, ironic, or tragic, but that's the way it is on this side of the Great Divide.

The Santa Maria River, which ends in the Pacific Ocean, is only 25 miles long because it begins—so named—at the confluence of two longer meandering rivers that drain the far reaches of the basin. Through these rivers, the Sisquoc and the Cuyama, the watershed extends deep into the rugged, desiccated, and crumbling San Rafael Mountains as the main drains for the Las Padres National Forest, extending eastward to the base of Mount Pinos, just 15 miles shy of Interstate 5 at the Grapevine and 100 miles, as the crow flies, from the ocean.

Along the way, the Cuyama River drainage supports the small remote agricultural areas of Ventucopa and Cuyama (with the recently and curiously transforming former oil town of New Cuyama) before entering Twitchell Reservoir, a Bureau of Reclamation project from 1958 designed to hold back floodwaters and recharge the aquifer below. The reservoir, also dry most of the time, looms above the confluence and origin of the Santa Maria River, down in the flat part of the Valley, which is one of the most intensive agricultural areas in the nation.

The east end of the agricultural zone is replete with wineries, part of the Santa Barbara viticultural district that extends into the adjacent Valleys of Santa

Ynez and Los Alamos, brought into further notoriety by the 2004 film, *Sideways*, whose locations are referred to in tours of the dozens of wineries of the region. Many of these wineries cover rolling oak-studded lands of former cattle ranches, which begat another thing the region is known for: Santa Maria style barbeque. Then as now, buzzards are a constant sight in the sky, circling endlessly over these dry hills.

As depicted in *Landfill*, the *terroir* of the Santa Maria Valley is composed primarily of industrial-scale agricultural production and consumption. The municipal landfill of the region is a mile-long mound along the Santa Maria River: large but not atypical. On its east end, plastics and bulk waste materials are processed and ground up into aggregate piles at the end of Sugar Road.

Santa Maria's farms produce vast quantities of broccoli, carrots, cauliflower, celery, lettuce, and squash, chilled in cooling warehouses dotting the Valley. It is also one of the nation's largest producers of strawberries (home of the annual Strawberry Festival), which are grown in fields covered entirely in plastic sheeting.

Located in California's Central Coast region, many people have driven through the Valley and the city of Santa Maria along Highway 101, between San Francisco to Los Angeles, probably without giving it much thought. The city, which shares its name with the first of Columbus's ships to come to the New World, is the largest community in the county—bigger than the city of Santa Barbara. Its urbanized area spans the wide agricultural flatlands of the Valley from north to south, with new highway motels and malls on the northeast side and industrialized farming and transportation operations on the southwest side. These include the massive greenhouse of Windset Farms, the largest agricultural employer in the area, and vegetable packing plants for major national growers like Pictsweet, Bonipak, and Driscoll's, which supplies nearly a quarter of the nation's strawberries.

Other industries have also come to the Valley as well. Located in an industrial park next to the airport, the Okonite Company makes long-distance electrical transmission cable, wound on huge spools visible in the yard outside the plant. Next to it is Safran, a French aerospace company, which employs nearly 1,000 people in town making seats and cabin components for airplanes. Just over the hill south of town is Vandenberg Air Force Base, the nation's West Coast spaceport and missile launch complex and the largest employer of Valley residents.

The oil industry has been active in the region for more than a century and still operates more than 1,000 wells there. The Santa Maria Refinery, on the coast north of town, is the only refinery in the region. It processes 44,500 barrels of crude per day from local wells, shipping most of it by pipeline to a refinery in Rodeo, near San Francisco, and makes sulfur fertilizer products that are used locally. In the hills south of town, on Black Road, is the Casmalia Landfill. It was established for local agricultural and industrial waste during the 1970s, then was expanded into one of the major official hazardous-waste disposal sites in California, accepting PCBs, solvents, and pesticides from all over the region. It was shut down 30 years ago but remains active as one of 200 or so Superfund sites in the state.

Through this all, the Santa Maria River meanders on, along the bottom of the Valley, as a slowly moving aquifer and as surface water, after a heavy rain. It flows past the last community, the well-preserved old town of Guadalupe, past the last new housing development on the edge of town, and the last municipal wastewater plant draining into the channel. Then past the last agricultural fields and the last oil field, now as a flooded channel, looking like a normal river for its last mile through the Guadalupe Dunes to the Pacific Ocean. Or nearly.

The water is pooled up behind the beach into a static lagoon, as there hasn't been enough rain to push it through to the ocean in more than a year. Which is unusual. At the top of a windswept dune overlooking the lagoon, clusters of white plaster and wood fragments can be seen emerging from the sand. This is the Ancient Egypt set from Cecil B. De Mille's 1923 film, *The Ten Commandments*, buried there when shooting ended a century ago. Ruins from the epic, cinematic beginning of the current age.

The Santa Maria Valley is an exemplary conveyor, moving the spent mix of agricultural waste and human matter to the nearby ocean: materials made by "man" merged with the materials of the earth, which then dissipate into the geologic. In *Landfill*, Brett Kallusky shows what happens, locally and globally. He vividly describes a landscape that is mounded and bound, defiled and deflated. Like a West Coast version of *A Tour of the Monuments of Passaic, New Jersey*, the artist Robert Smithson's pioneering foray into that landscape in 1967, Kallusky's book is a compelling depiction of multiples, monotony, dumps, slumps, and lumps. Everything, after all, is ground up at the end of the road. Even the road itself.

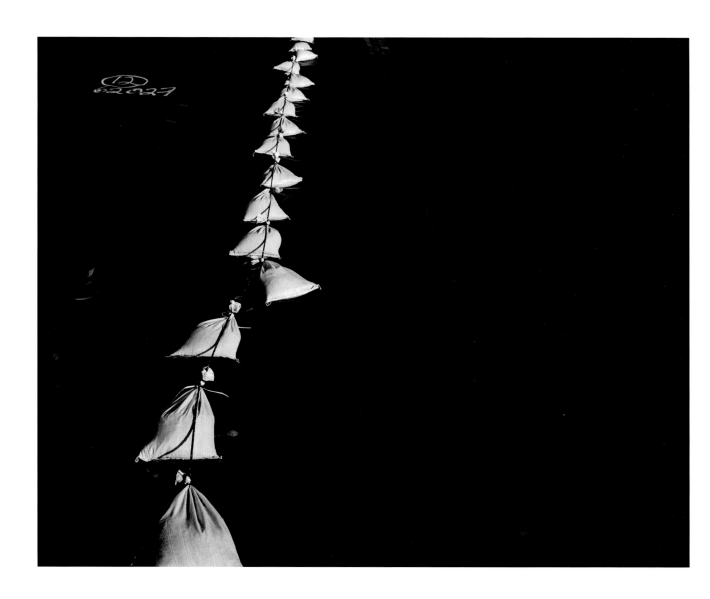

List of Plates

All photographs in this book were made between 2013 and 2019 in and around the Santa Maria Valley in Central California, including Santa Barbara and San Luis Obispo Counties. Dimensions are listed as width x height.

2 Road Gravel, Santa Maria Regional Landfill (2015). 24 x 20 inches.

4–5 NHIS (Non-Hazardous Hydrocarbon Impacted Soils), Santa Maria Regional Landfill (2015). 48 x 20 inches (diptych).

6 Runoff Drain, Santa Maria Regional Landfill (2015). 24 x 20 inches.

9 Baled Plastic, Santa Maria Regional Landfill (2013). 24 x 20 inches.

10 Mini-Kracken (Bird Abatement), Santa Maria Regional Landfill (2013). 24 x 20 inches. Kim and John Golden's Falconry is a unique program that replaced fireworks or ammunition to scare seagulls and crows away from the landfill.

17 Baled Plastic, Santa Maria Regional Landfill (2013). 24 x 20 inches.

19 Agricultural Plastic, Santa Maria Regional Landfill (2017). 20 x 24 inches.

21 Unloading Waste, Santa Maria Regional Landfill (2017). 24 x 20 inches.

23 Agricultural Plastic, Santa Maria Regional Landfill (2017). 24 x 20 inches.

24–25 Baled Plastic, Santa Maria Regional Landfill (2017). 72 x 33.5 inches (diptych).

27 Trash Dumpster, Santa Maria Regional Landfill (2015). 24 x 20 inches.

28–29 Agricultural Landscape, Santa Maria (2017). 48 x 20 inches (diptych).

31 Remediated Soil, Santa Maria Regional Landfill (2015). 24 x 20 inches.

33 Berry Hoop Houses, Santa Maria (2015). 24 x 20 inches.

35 Irrigation Pipes, Santa Maria (2017). 24 x 20 inches.

37 Drainage Ditch, Santa Maria Regional Landfill (2017). 24 x 20 inches.

39 Remediated Soil, Santa Maria Regional Landfill (2013). 24 x 20 inches.

41 Asphalt, Santa Maria Regional Landfill (2017). 24 x 20 inches.

43 Strawberry Field, Nipomo (2017). 50 x 40 inches.

45 Irrigation Well, Nipomo (2017). 24 x 20 inches.

47 Cooler Sign, Nipomo (2017). 20 x 24 inches.

49 Plastic Recycling Containers, Santa Maria Regional Landfill (2015).
 24 x 20 inches.

50 Strawberries in Plastic, Nipomo (2017). 16 x 20 inches.

51 Strawberry Containers, Santa Maria (2019). 24 x 20 inches.

53 Barnside, Santa Maria (2017). 24 x 20 inches.

55 Groundwater Test Well, Santa Maria Regional Landfill (2015).
 24 x 20 inches.

57 Dune Break, Nipomo (2017). 20 x 24 inches.

59 House, Santa Maria (2017). 24 x 20 inches.

61 Covered Truck, Santa Maria (2017). 24 x 20 inches.

63 The Witch (Bird Abatement), Santa Maria Regional Landfill (2013).
 24 x 20 inches.

65 Juan's Peach Tree, Santa Maria Regional Landfill (2017). 20 x 24 inches.

67 Agricultural Field, Nipomo (2017). 24 x 20 inches.

68 The Old Santa Maria Mesa Road Bridge, Santa Maria (2017).
 24 x 20 inches.

69 Abandoned Hot Tub, Santa Maria River (2017). 24 x 20 inches.

71 Abandoned Box Spring and Mattress, Santa Maria (2017). 24 x 20 inches.

73 Housing Development, Nipomo (2017). 24 x 20 inches.

75 Harris Hawk (named Kate) and Crows, Santa Maria Regional Landfill (2013). 24 x 20 inches. Kate scares off nuisance crows at the landfill.

76 Aerial Image of the Casmalia Resources Superfund Site, Casmalia (2019). The Casmalia Resources Superfund Site is an inactive, 252-acre commercial hazardous-waste storage, treatment, and disposal facility in northern Santa Barbara County.

77 Near the Casmalia Resources Superfund Site, Santa Barbara County (2019). 24 x 20 inches.

79 Near the Casmalia Resources Superfund Site, Santa Barbara County (2019). 24 x 20 inches.

80–81 Panorama, Casmalia Resources Superfund Site, Santa Barbara County (2019). 48 x 20 inches (diptych).

82 Frank Aston's Photograph of the 1926 Union Oil Tank Farm Fire, San Luis Obispo. Courtesy of San Luis Obispo County Historical Museum. As of 2019, four-million metric tons of remediated soil that were polluted by oil from this disaster and from other areas have been brought to the landfill.

83 Site of the 1926 Union Oil Tank Farm Fire, San Luis Obispo (2017). 24 x 20 inches.

84 Trash Dumpster, Santa Maria Regional Landfill (2013). 24 x 20 inches.

88 NHIS Soil Cell, Santa Maria Regional Landfill (2015). 24 x 20 inches.

92 Volunteer Tobacco Plant, Santa Maria Regional Landfill (2019). 20 x 24 inches.

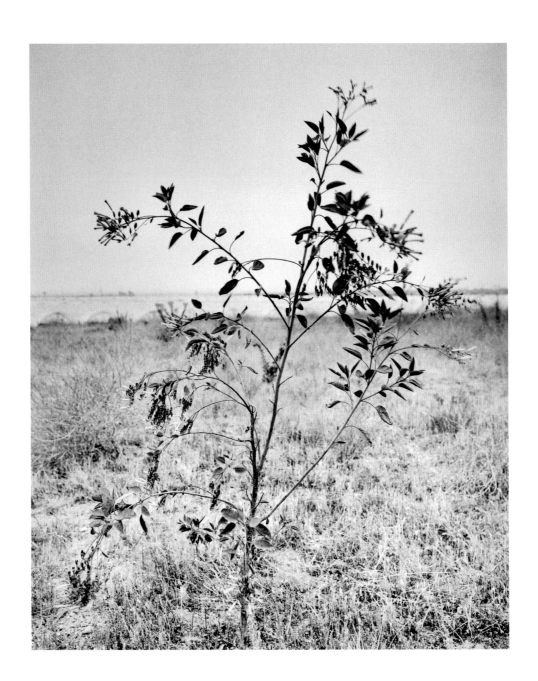

Acknowledgments

I would have been unable to begin this project without the incredible material help and encouragement from Dan Vossler and Buck Waterfield in California. Without their introductions and access to the Santa Maria Regional Landfill, I could not have made the photographs from that place. In addition, the iterations of this work, in exhibition and sequencing through studio visits, are indebted to the eyes and thoughtful feedback of my mentor, David Heberlein, as well as Jaime Alvarez, Melissa Borman, Byron Brauchli, Eric William Carrol, Bernice Ficek-Swenson, David Goldes, Pao Ha Her, Yasufumi Nakamori, Anthony Marchetti, Paul Wegner, and Jenny Wheatley.

I also express gratitude to Jesse Vestermark and Jessica Holada from the Kennedy Library at California Polytechnic State University, San Luis Obispo, for aiding me in the research for this project; to my former student, Molly Ruoho, for her assistance; and to Mary Virginia Swanson and the participants in her Master Photography Workshop of January 2019 in Tucson, Arizona, for their feedback, review, and encouragement of my work, in particular from Eric Kunsman and Jennings Sheffield.

This book would not have been possible without the guidance of Dr. Rebecca A. Senf, Chief Curator of Photography at the Center for Creative Photography; my publisher, George F. Thompson, who helped me develop the book and sequence the photos; his assistant, Mikki Soroczak, for her careful preparation of the manuscript; and book designer David Skolkin, for his artful presentation of my work. Nor was publication possible without the financial support of the Minnesota State Arts Board Artist Initiative Grant, a Faculty Research Grant from the University of Wisconsin-River Falls, and the generosity of Bill Press and Elana Auerbach and Jane and Chops Wong.

I thank my father, Chad Kallusky, who first brought photography to me; my sister, Elizabeth, and her husband, Aaron Deschu, for their support; and my mother, Barb Kallusky, who passed away in 2019 and taught me to accept what I see and to work to change things that need changing.

I'm indebted to the incredible support from Megan Vossler. Without her encouragement this book would not exist.

Finally, this book is dedicated to my daughter, Elsa, so that she can see a different world.

About the Author and Essayist

Brett Kallusky was born in 1975 in St. Paul, Minnesota, and grew up in Afton, Minnesota. He completed his B.F.A in photography at the University of Wisconsin-River Falls and his M.F.A. in photography at Cranbrook Academy of Art. Since 2007, he has taught photography full-time while maintaining an active photographic studio practice. He is currently an associate professor of art at the University of Wisconsin-River Falls. His photographs have appeared in *Aint-Bad Magazine* and *National Geographic Online*, and his previous book is *Journey with Views/Viaggio con Vista* (self-published, 2014). Kallusky has been a Fulbright Fellow to Italy, received three Minnesota State Arts Board Artist Initiative Grants and numerous Faculty Professional Development Grants from the University of Wisconsin-River Falls, and is a two-time finalist for the McKnight Fellowship for Photography and Visual Arts. He resides in Minneapolis, Minnesota.

Matthew Coolidge was born in 1966 in Montreal, Canada, and completed his B.F.A in geography at Boston University in 1990. He founded the Center for Land Use Interpretation in 1994 and has been its director since then. He lectures at numerous universities, has been on the faculty of the California College of Art, and has served on the Board of Directors of the Holt/Smithson Foundation. Under his guidance, the Center has produced dozens of publications, public programs, and exhibitions shown at its primary exhibition space in Los Angeles and at other temporary and permanent Center facilities in places that include Hinkley, California, Houston, Texas, Troy, New York, and Wendover, Utah. The Center has also presented programming at other institutions, including the Los Angeles County Museum of Art and the Smithsonian Institution.

About the Book

Landfill: Elegy for the Santa Maria Valley was brought to publication in an edition of 1,000 clothbound copies. The text was set in Minion, the paper is Perigord, 170 gsm weight, and the book was professionally printed and bound by Pristone Pte. Ltd. in Singapore.

Publisher and Project Director: George F. Thompson
Editorial and Research Assistant: Mikki Soroczak
Manuscript Editor: Purna Makaram
Book Design and Production: David Skolkin

The epigraph on page 8 comes from Heather Davis, "Life and Death in the Anthropocene: A Short History of Plastic," in Heather Davis and Etienne Turpin, eds., *Art in the Anthropocene: Encounters among Aesthetics, Politics, Environments, and Epistemologies* (London, UK: Open Humanities Press, 2015), 349.

Published in 2022. First clothbound edition.
Printed in Singapore on acid-free paper.

George F. Thompson Publishing, L.L.C.
217 Oak Ridge Circle
Staunton, VA 24401–3511, U.S.A.
www.gftbooks.com

30 29 28 27 26 25 24 23 22 1 2 3 4 5

The Library of Congress Preassigned Control Number is 202194496.

ISBN: 978-1-938086-87-8